# THIS BOOK BELONGS TO

..................................................

..................................................

Copyright @ 2019 Fairy Star All rights reserved.
No part of this book may be reproduced or transmitted in any form or by any means except for your own personal use or for a book review, without the written permission from the author.

The pages of this book are suitable for crayons and colored pencils for kids.
Each picture is printed on one side of 60 lb pure white paper to minimize scoring and bleed-through. It is also suitable for framing. Parents should teach children how to use this book and media properly.

The age when a child is ready to begin using coloring books varies from child to child.

www.ingramcontent.com/pod-product-compliance
Lightning Source LLC
Chambersburg PA
CBHW081444220526
45466CB00008B/2508